Color Me Delightfully Natural the African American

coloring book

capturing a personal essence of natural hair.

Color Me Delightfully Natural, *which is the product of the author's own inspired photographs illustrated into a coloring book uniquely designed for all ages*
L E Harrison-Diggs

Copyright © 2016 All rights reserved.

Purple Diamond Publishing

Purple Diamond Publishing

P.O. Box 8144

Virginia Beach, VA 23450

Purplediamondpublishing@gmail.com

Placing an order is easy

http://squareup.com/market/purple-diamond-publishing

&

www.createspace.com www.amazon.com

No part of this book may be reproduced or transmitted in any form or by any means, electronic or mechanical, including photocopying, recording or by any information storage and retrieval system, without written permission from the author.

Color Me Delightfully Natural the African American

coloring book

capturing a personal essence to natural hair.

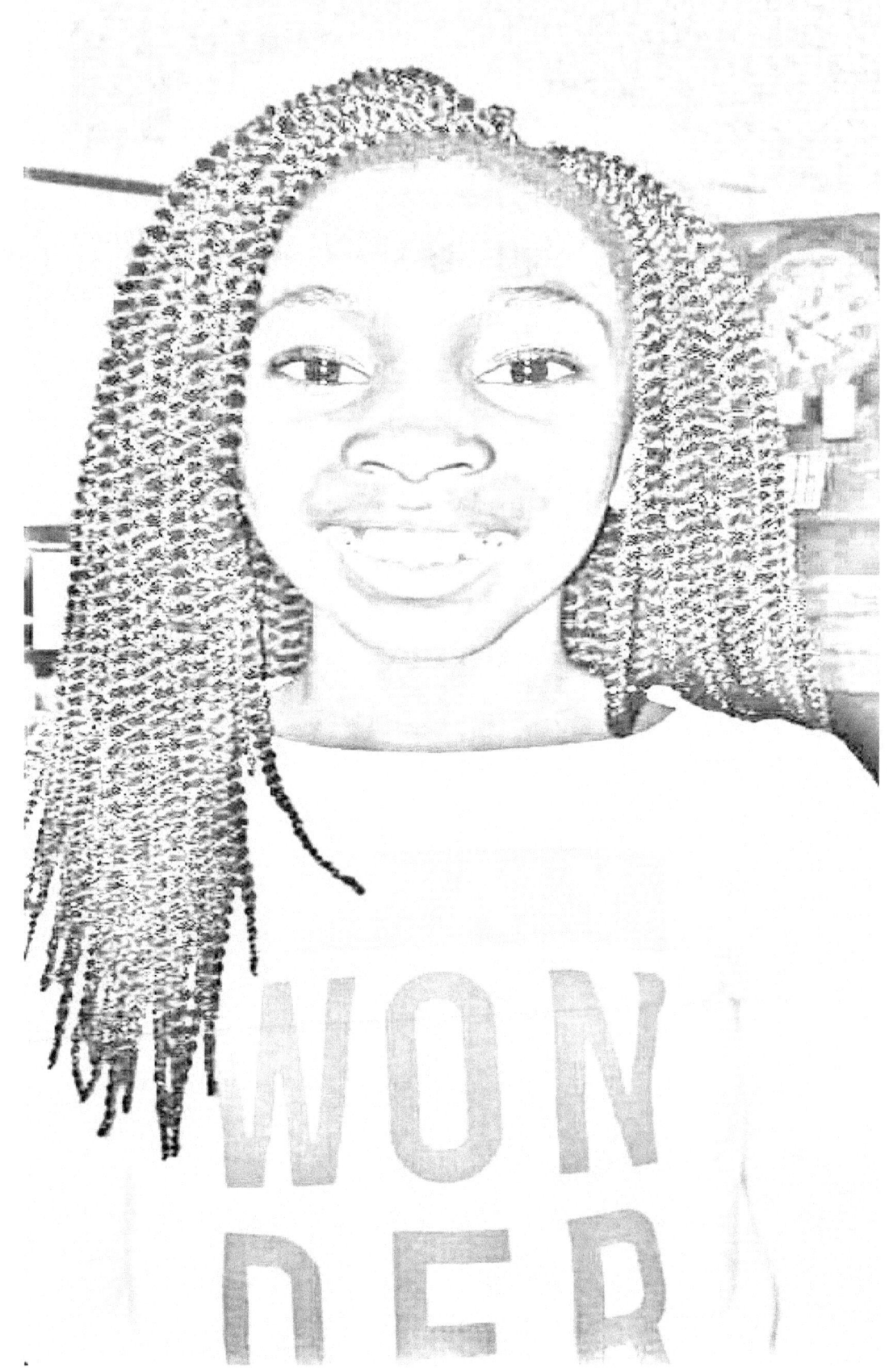

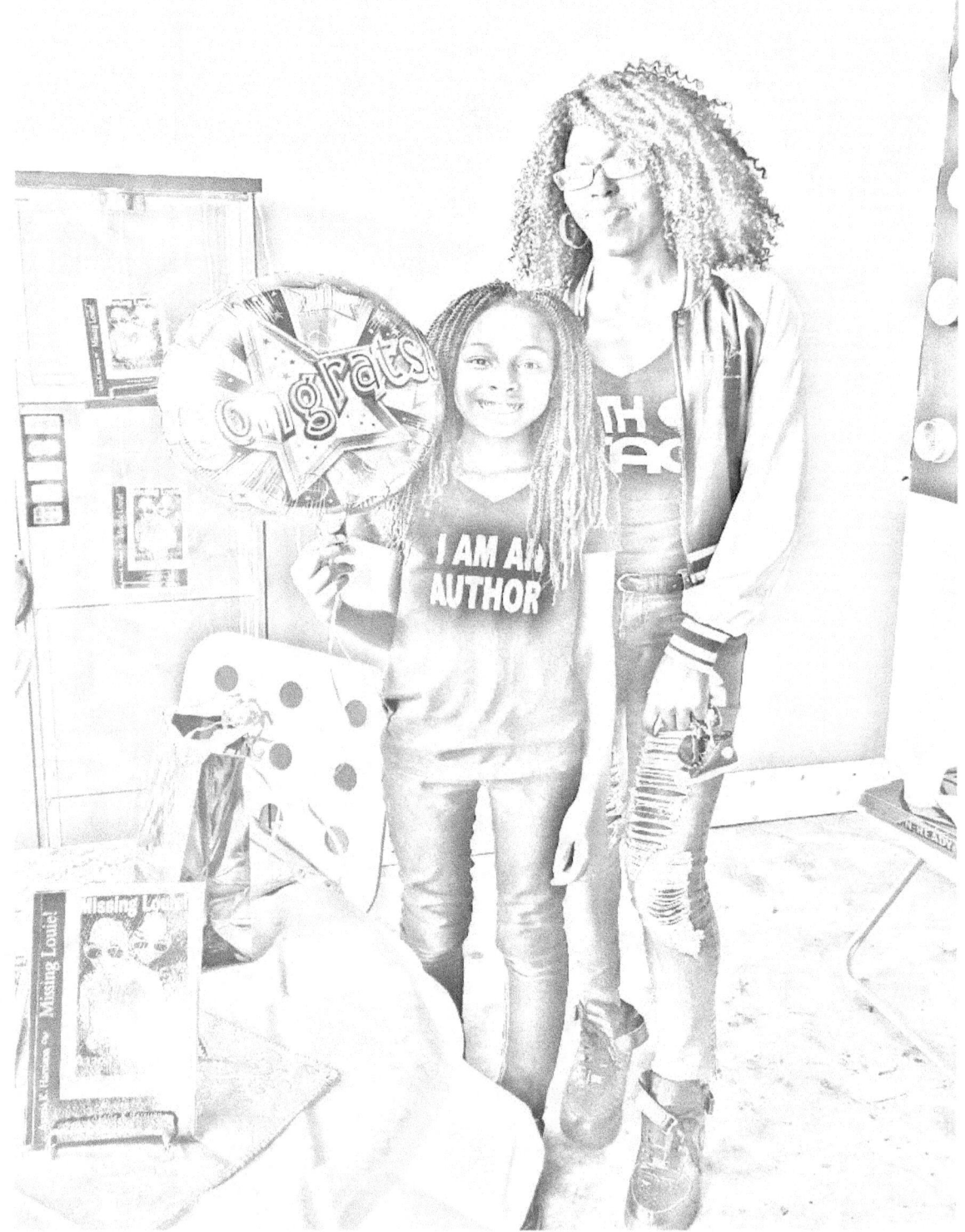

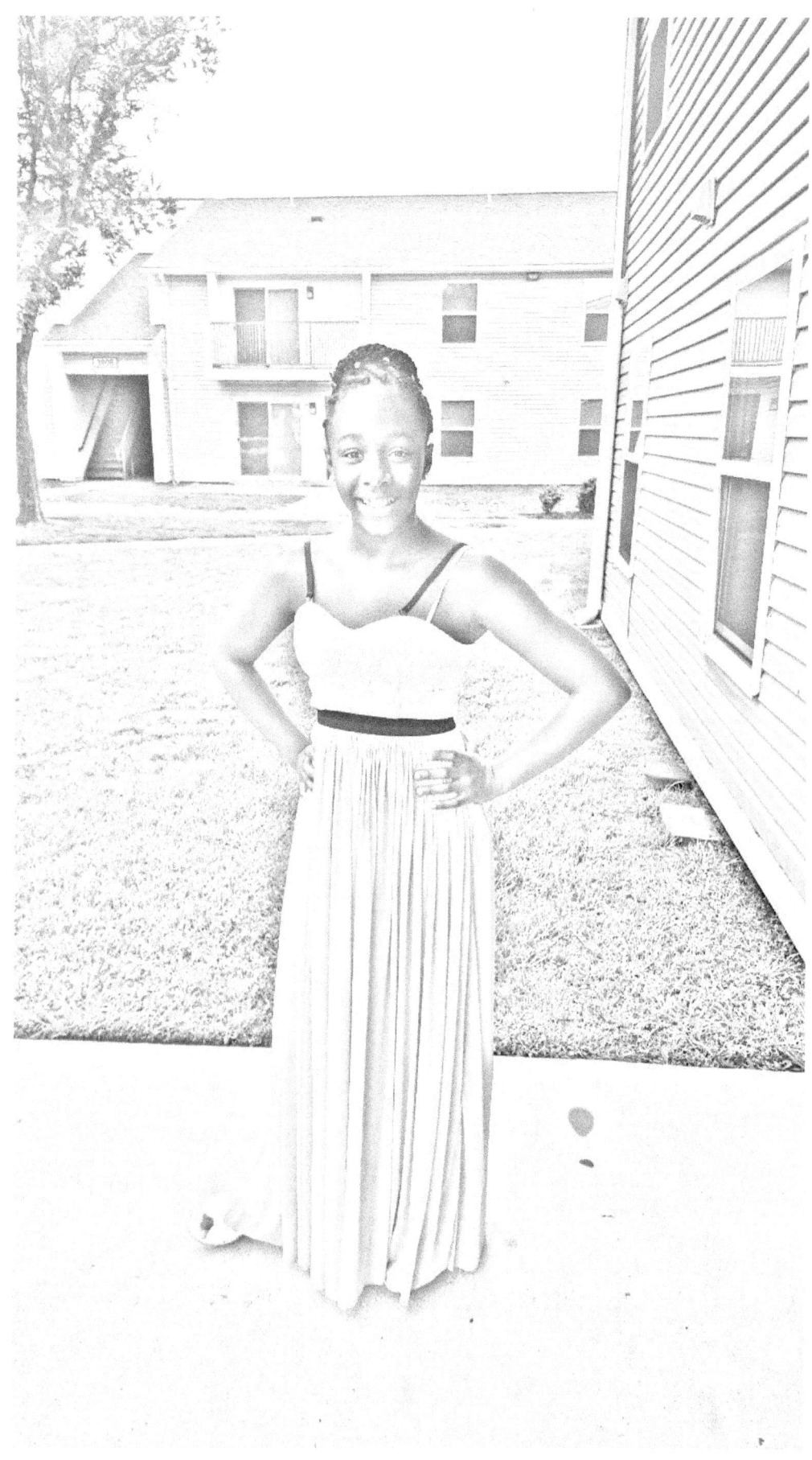

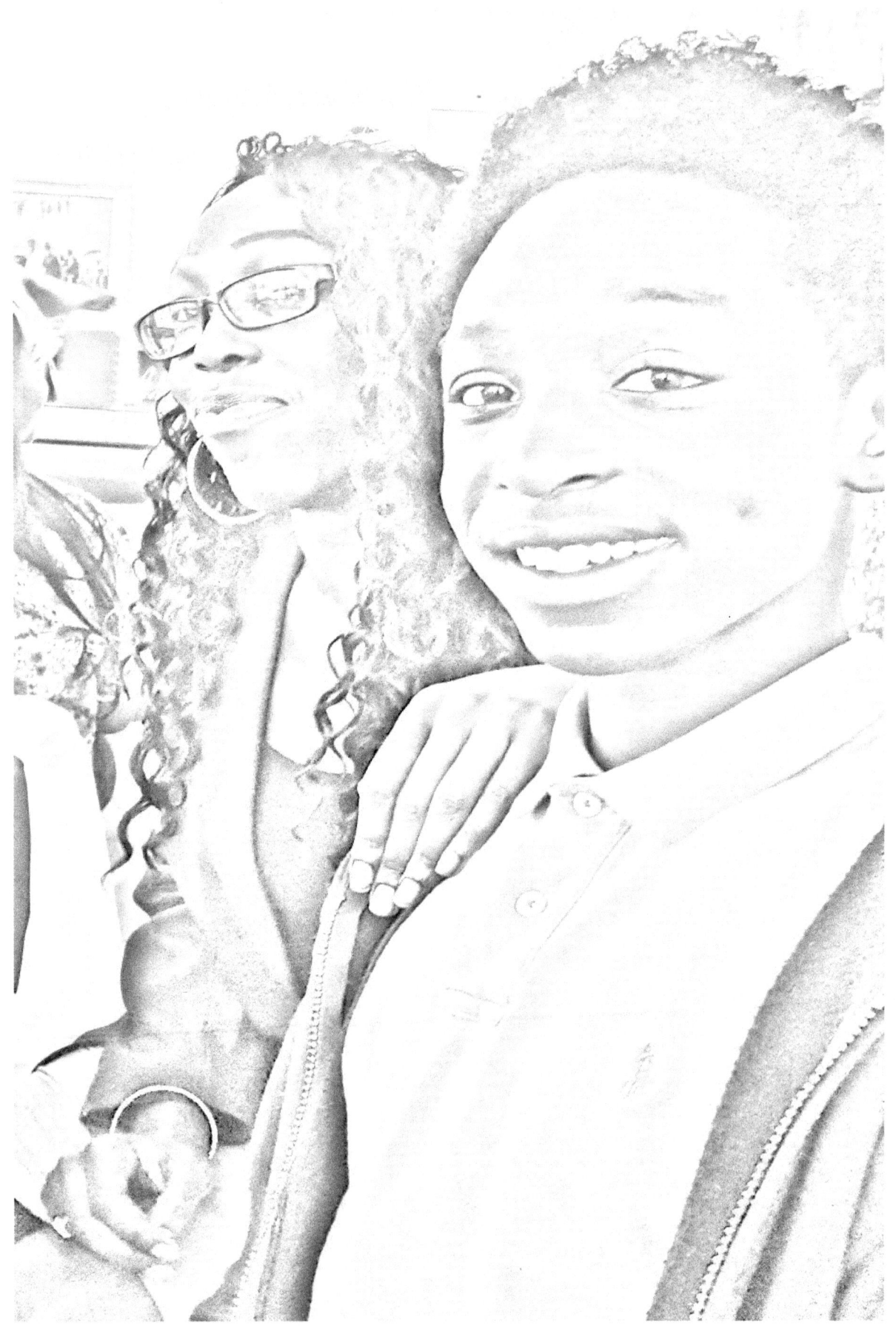

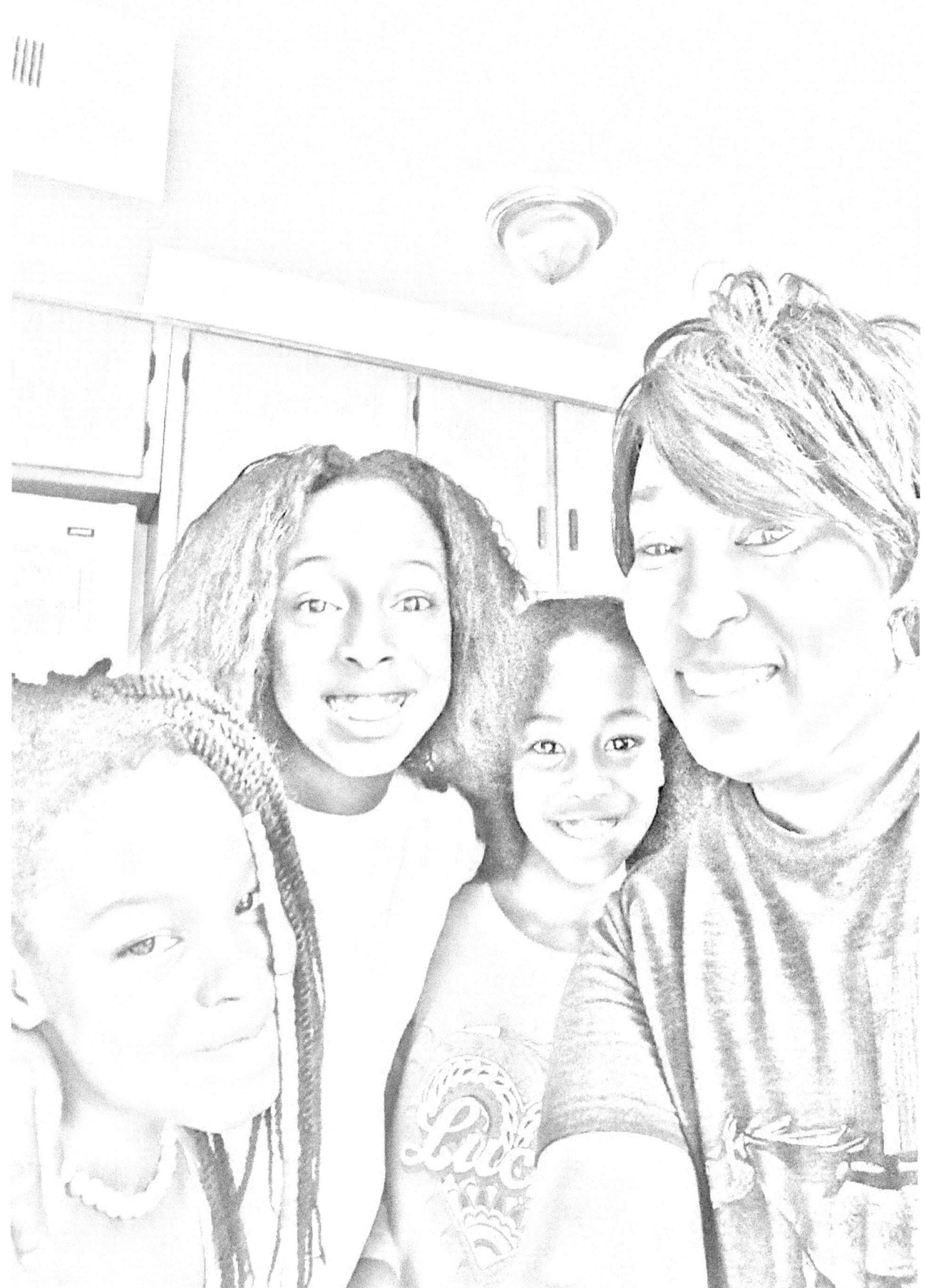

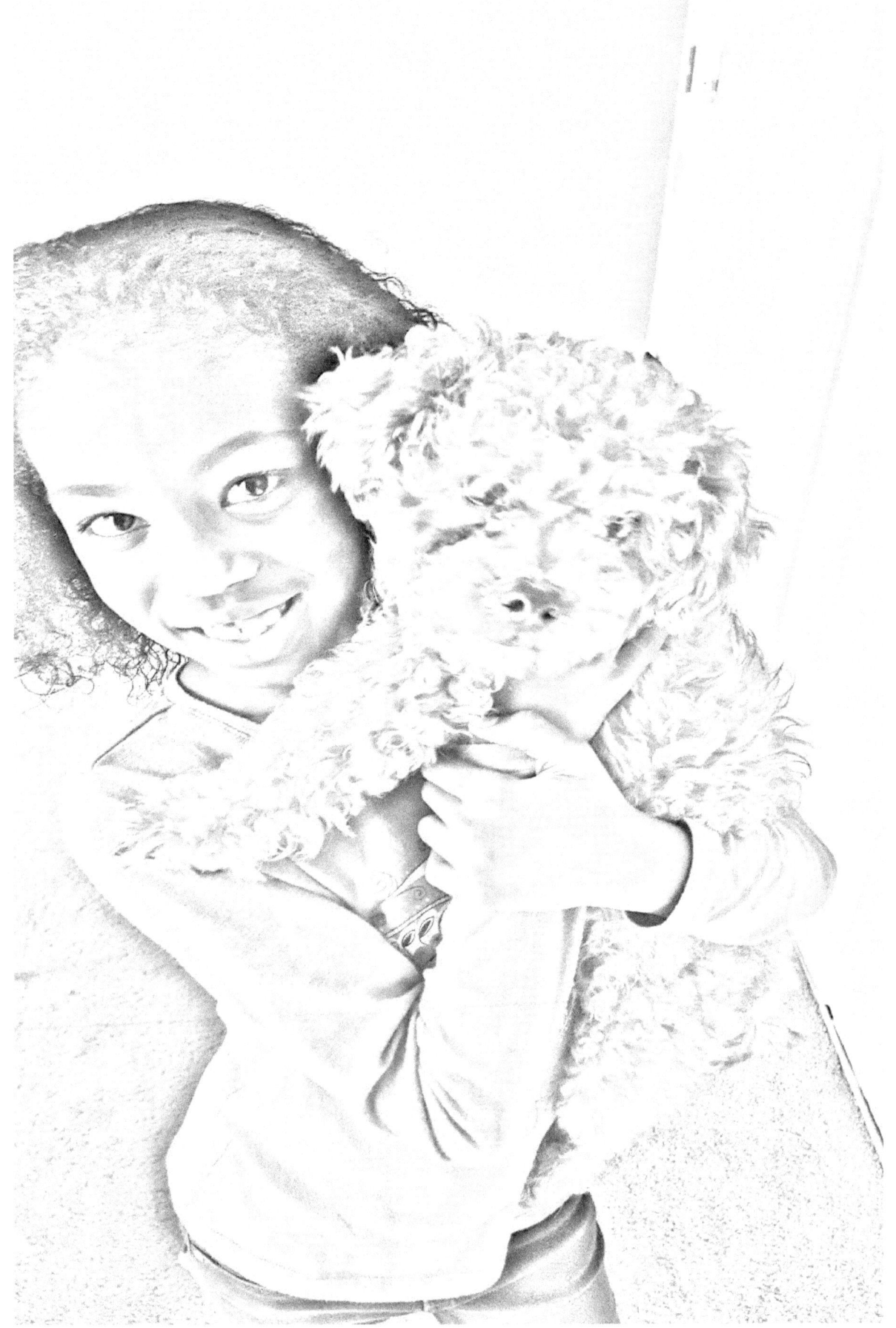

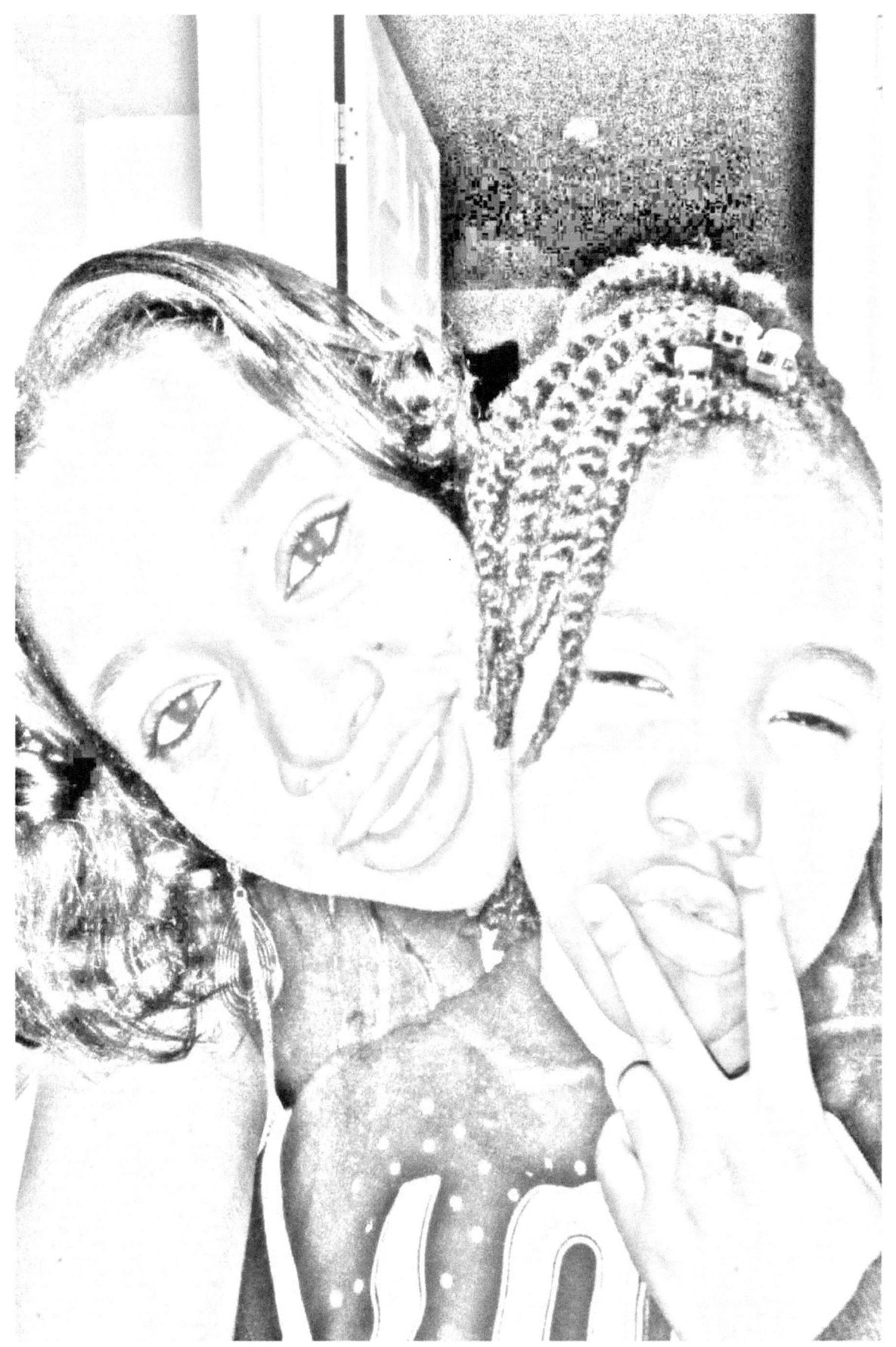

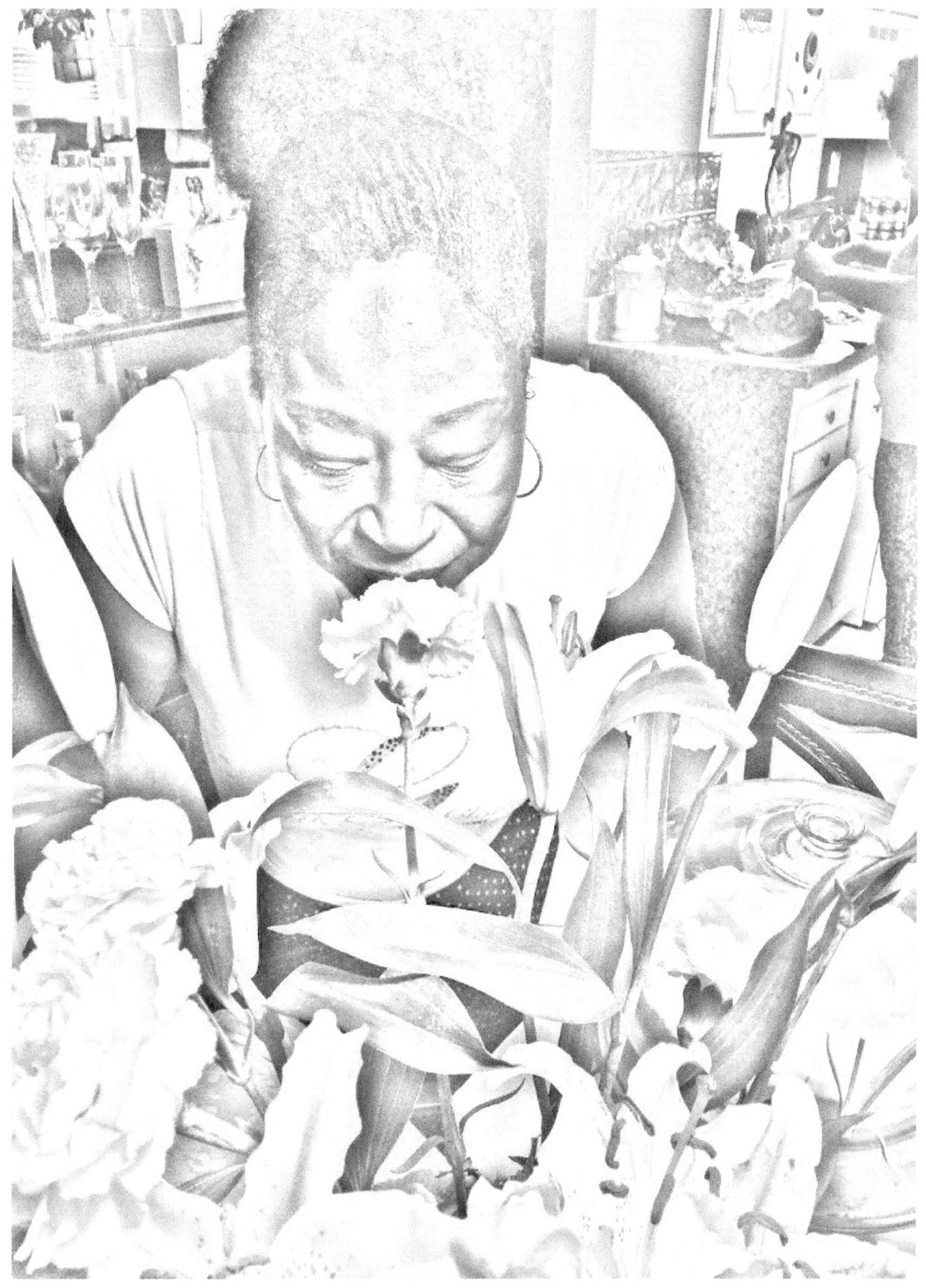

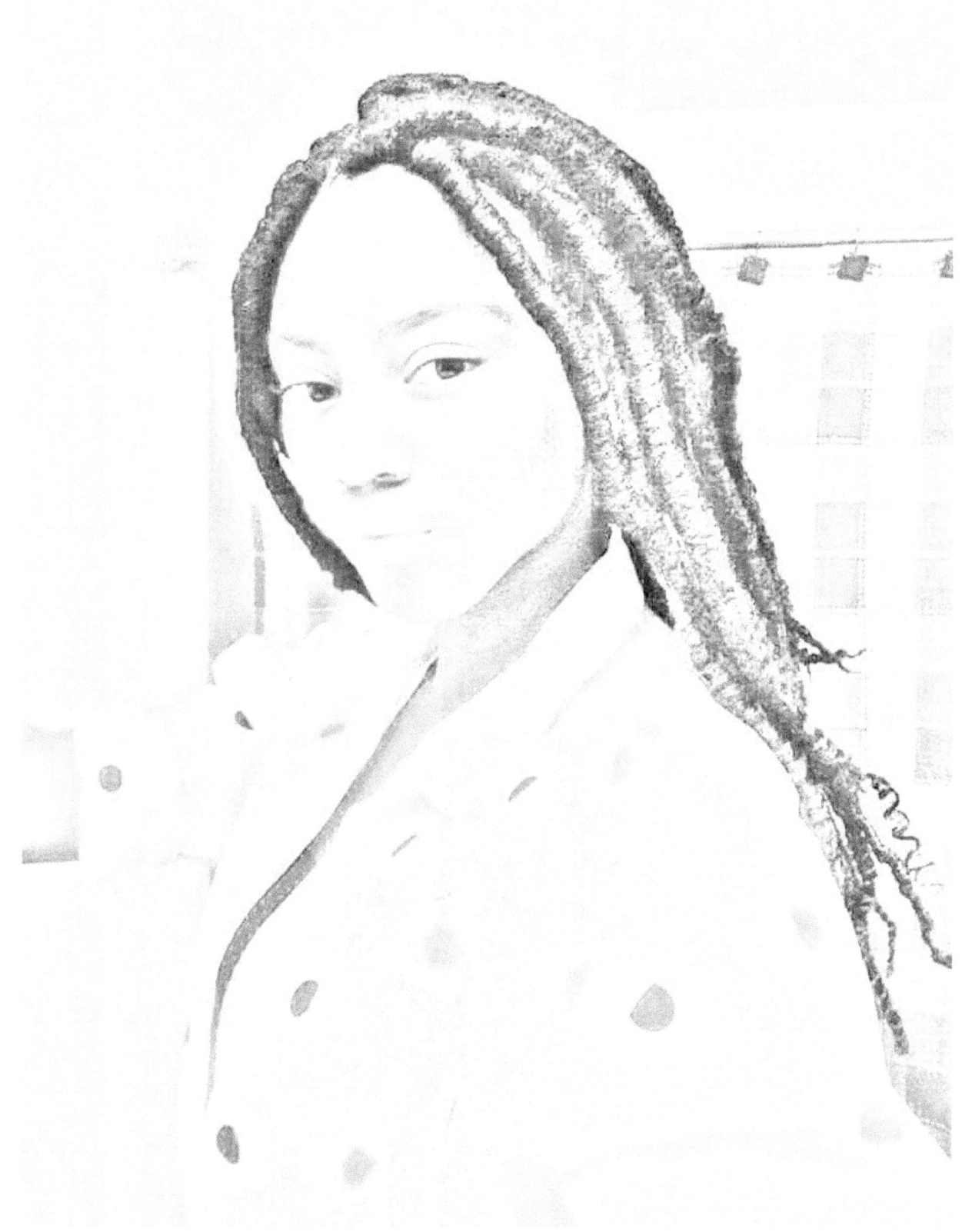

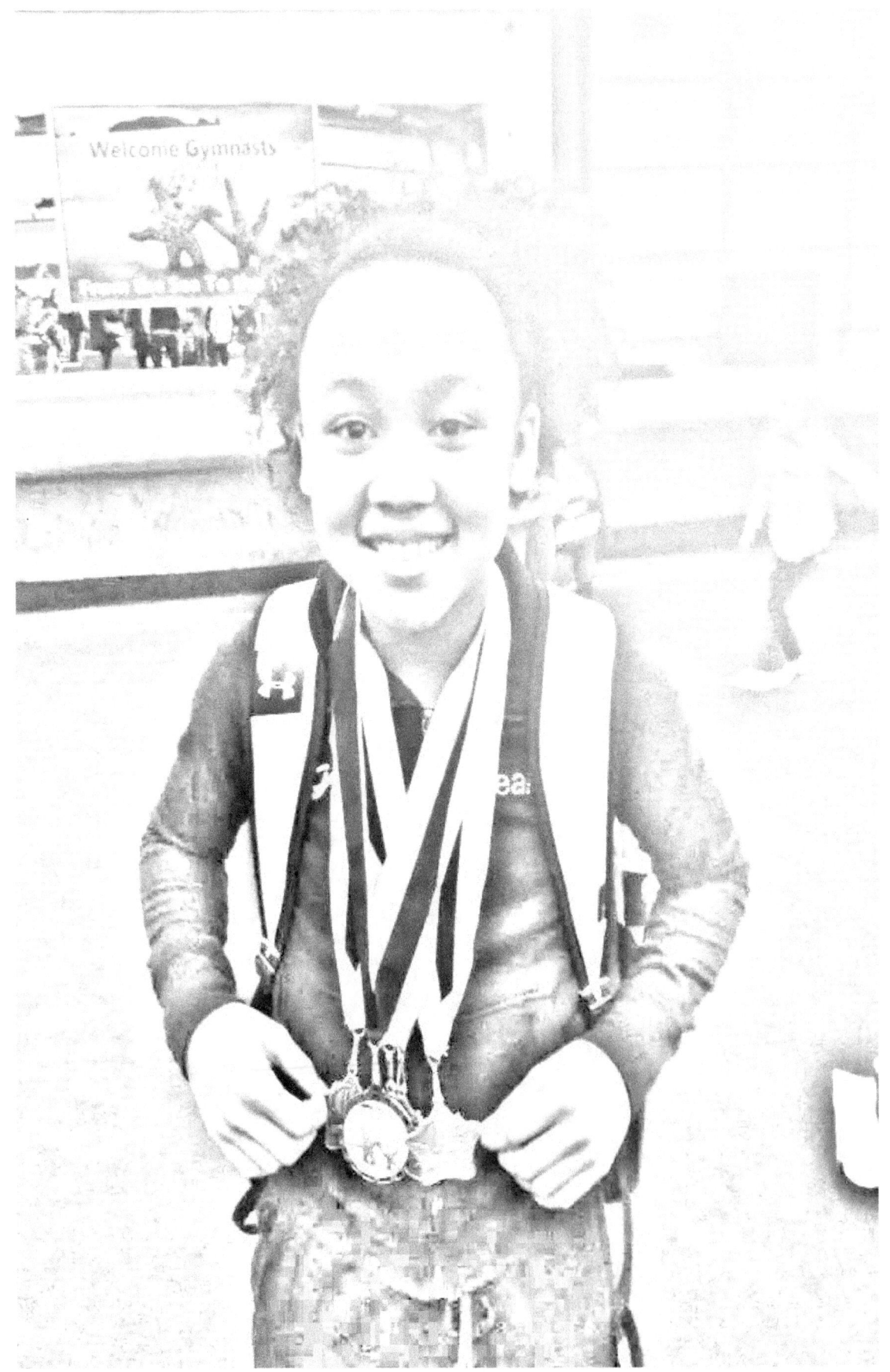

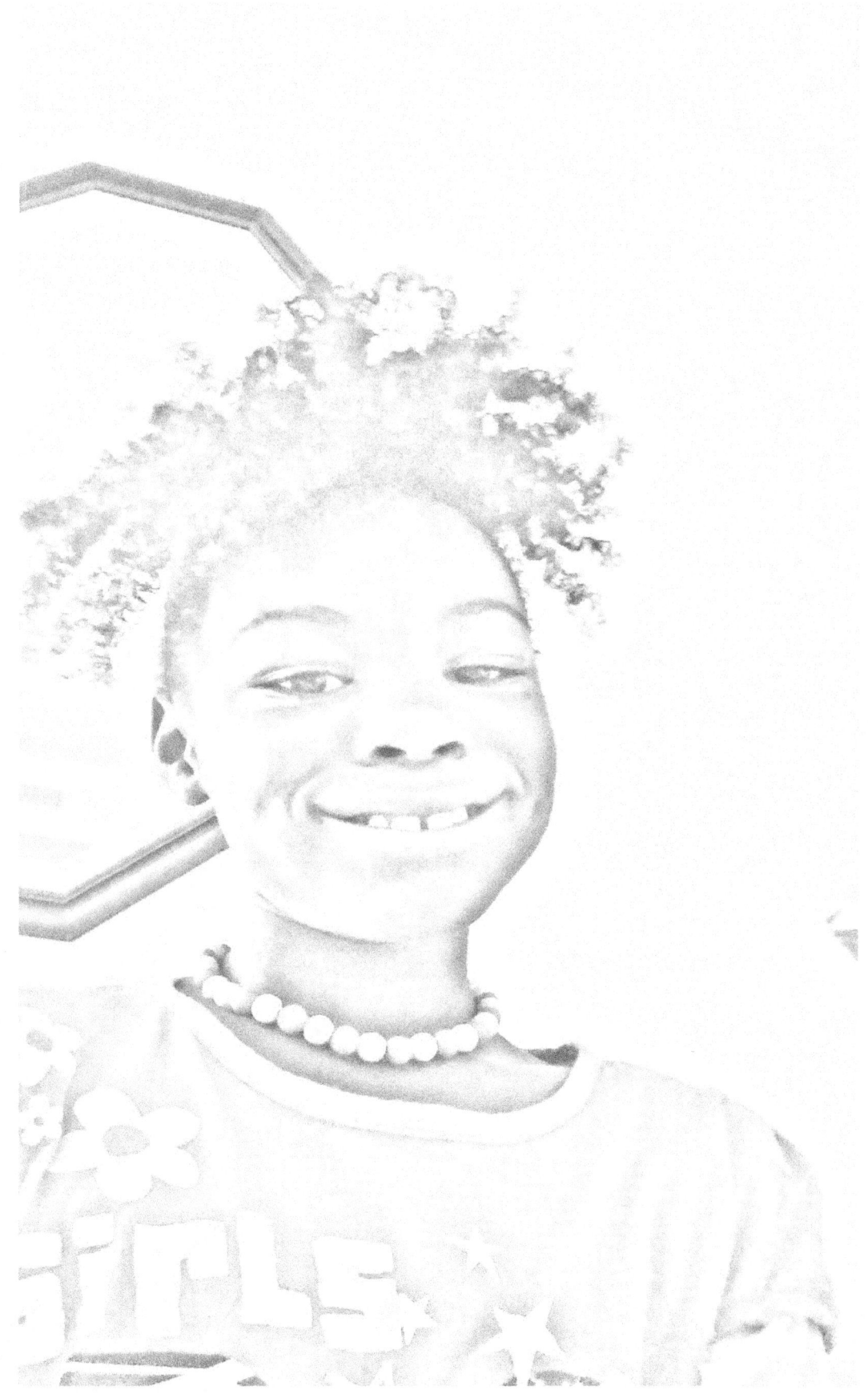

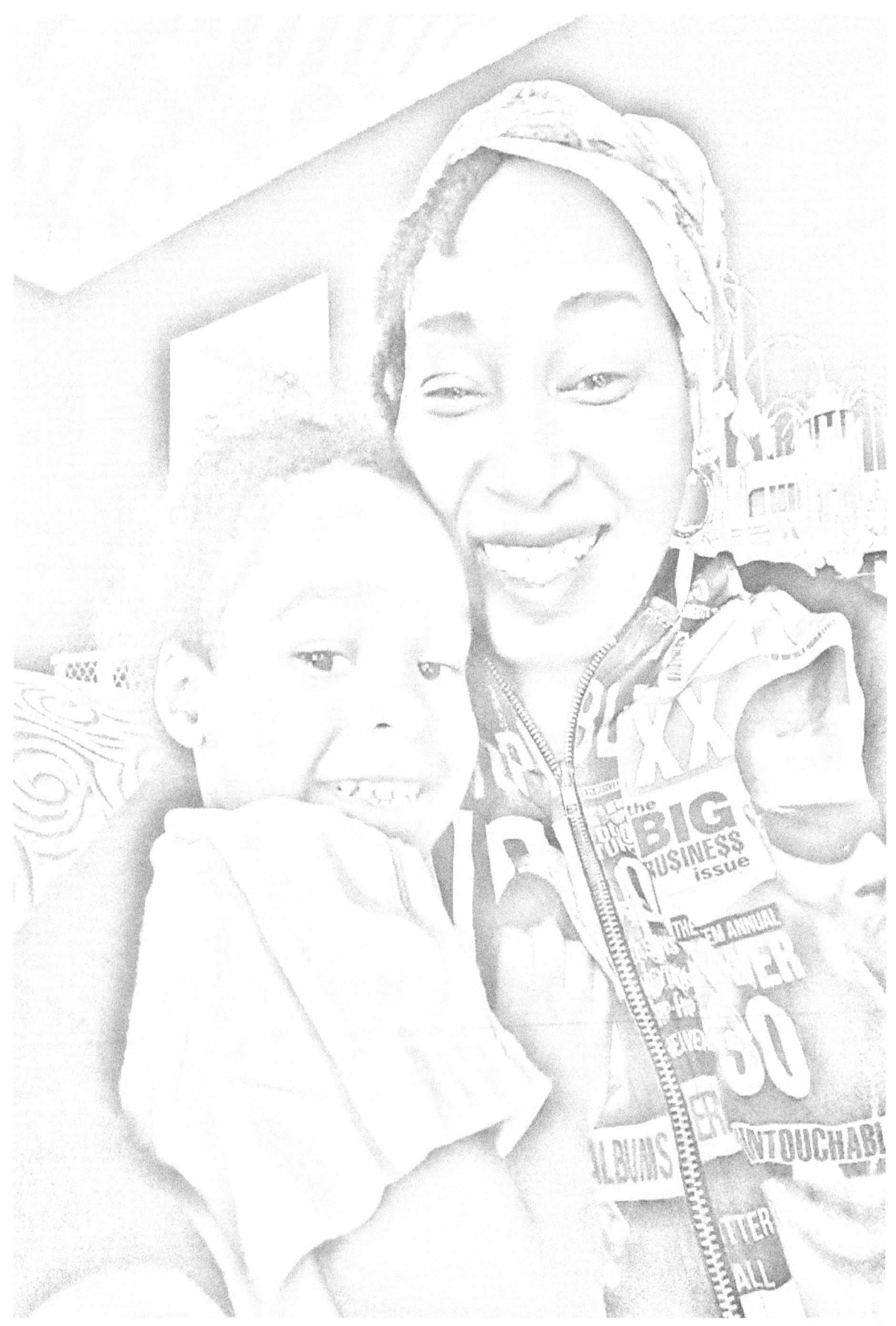

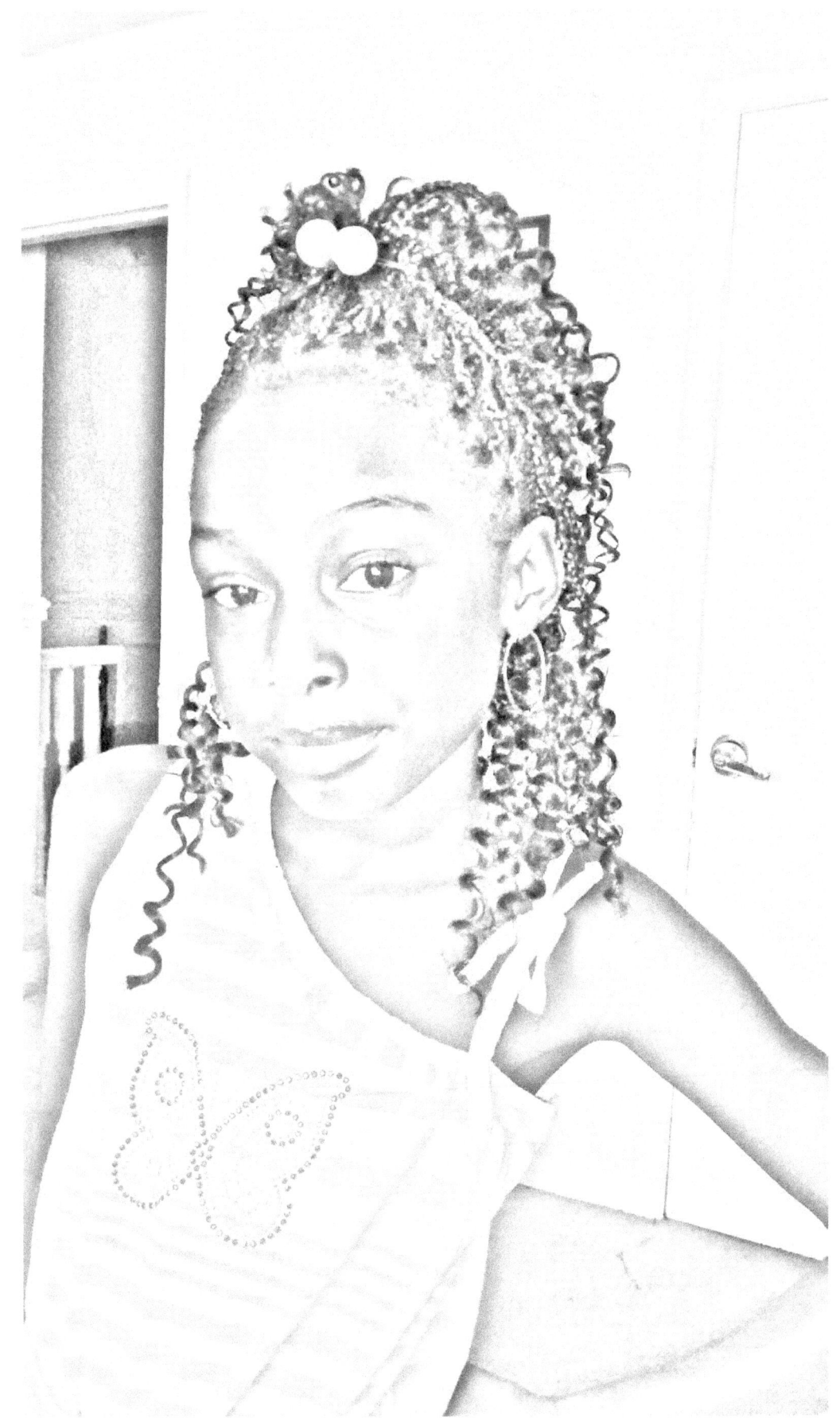

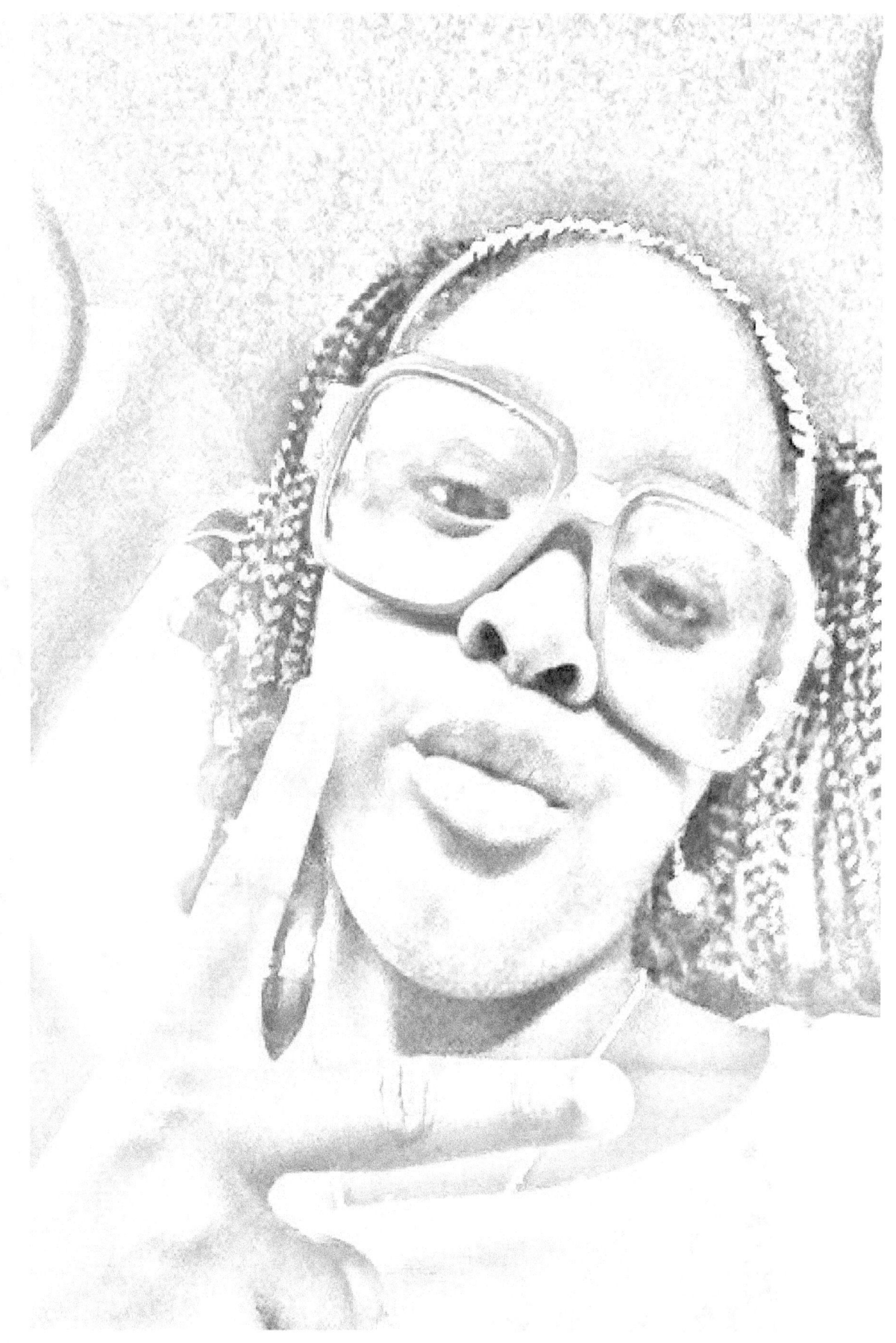

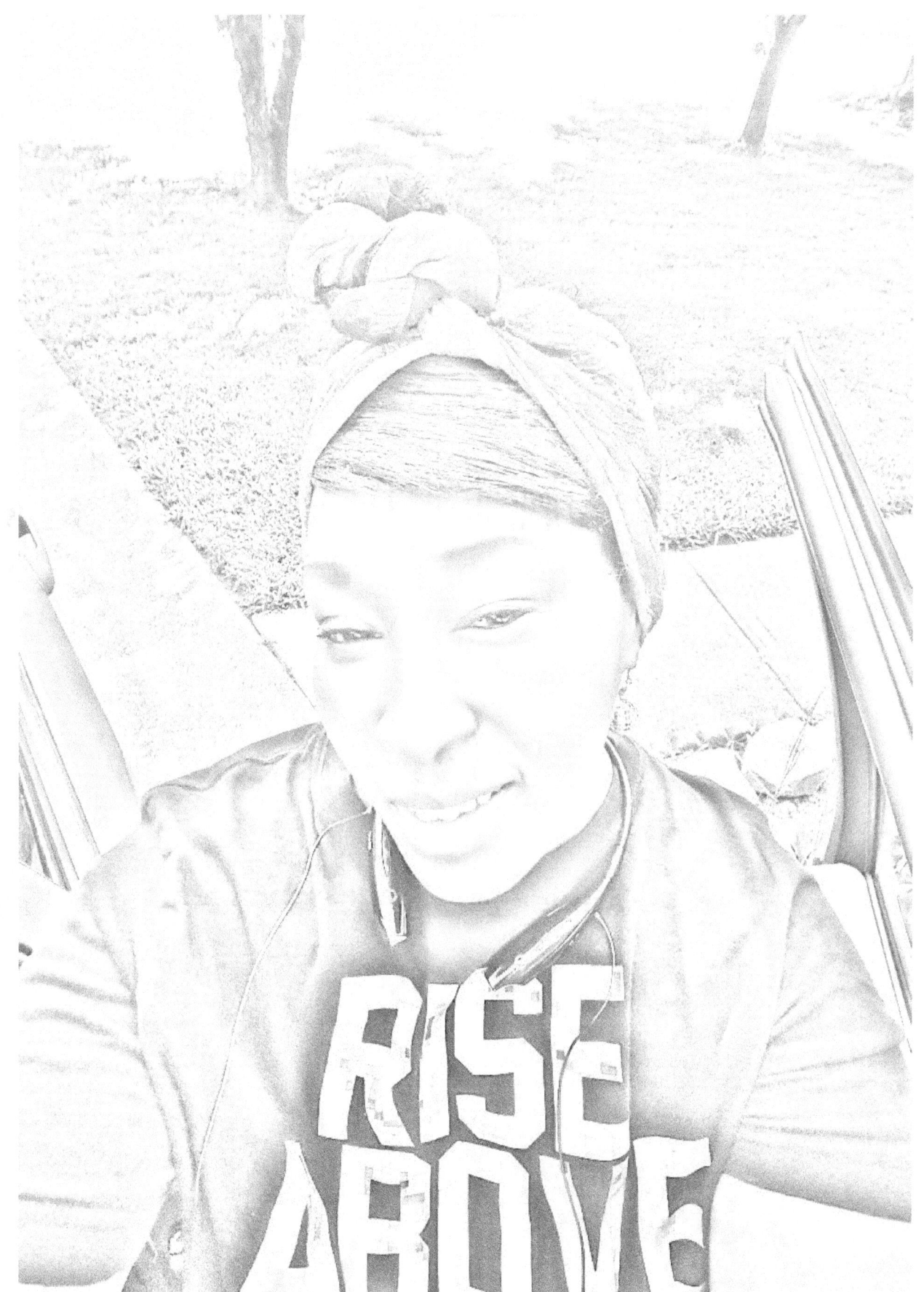

We Hope You Enjoyed...

Color Me Delightfully Natural the African American

coloring book

capturing a personal essence of natural hair.

Look for other Children's Reads by The Author L E Harrison-Diggs

Published by Purple Diamond Publishing

I Love Bubble Gum

Mommy, Daddy, Daddy I Can Sing!

Big Brother, Little Sisters!

RJ Plays Football!

Mom, I Am A Winner!

Graduation Day!

Caring is Sharing!

Grandma's Wings

Daddy, I'm Not Sleepy!

MJ Goes To The Dentist!

Grandma's Wings

Color Me Delightful for Yet I Am Brown

Available for Purchase

www.createspace.com

www.amazon.com

http://squareup.com/market/purple-diamond-publishing

www.ingramcontent.com/pod-product-compliance
Lightning Source LLC
Chambersburg PA
CBHW080532190526
45169CB00008B/3129